MASTERPIECES OF IMPRESSIONISM

Chronicle Books · San Francisco

W ith the Impressionist school, the sovereignty of light is at last asserted. Light explodes, it invades the being, it imposes itself as conqueror, it dominates the world, which is a support to its glory, an instrument of its triumph.

Who does not understand henceforth that today the eye sees differently from yesterday? It has, after long efforts, discovered nature, dark at first, now luminous. That's not all. Who can say what joys are in store for the refinement of sight, by the ulterior evolution of our sense of sight?

When I saw Monet with his three canvases in front of his poppy field, changing his palette as the sun ran its course, I had the feeling of a study of light all the more precise because the immobile subject underscored luminous mobility more strongly.

It was the beginning of a revolution, a new way of seeing, of feeling, of expressing. That poppy field, bordered by its three elms, marked an era in perception as well as in the expression of things.

Georges Clemenceau, 'The Cathedrals Revolution', in *La Justice*, 1895

CLAUDE MONET, A FIELD OF POPPIES NEAR ARGENTEUIL, 1873

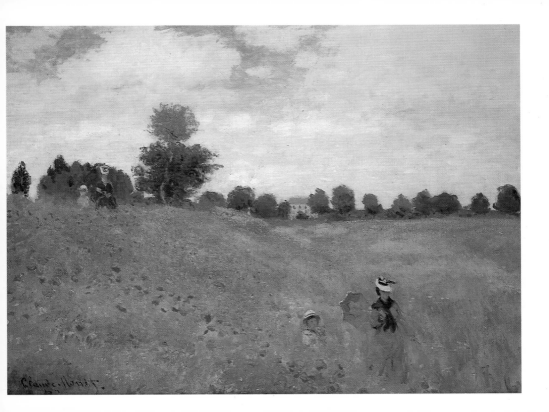

There were already many bistrots; but especially there was the Moulin de la Galette, where every Saturday night and Sunday the shop girls and clerks from the north side of Paris used to come and dance. The present 'Moulin' building did not then exist, of course; there was merely a big shed constructed around two windmills, which had just ended a long and honourable career of turning out flour. As factories began to replace the wheat-fields in the flat land around Saint-Denis, supplies of grain for the Montmartre windmills dwindled to nothing. Happily, the open-air café came in time to save this charming relic of another day from being pulled down. Renoir loved the place because its simple amusements typified so well the 'good-natured' side of the common people of Paris.

Jean Renoir, *Renoir, My Father*, 1958

PIERRE-AUGUSTE RENOIR, LE MOULIN DE LA GALETTE, 1876

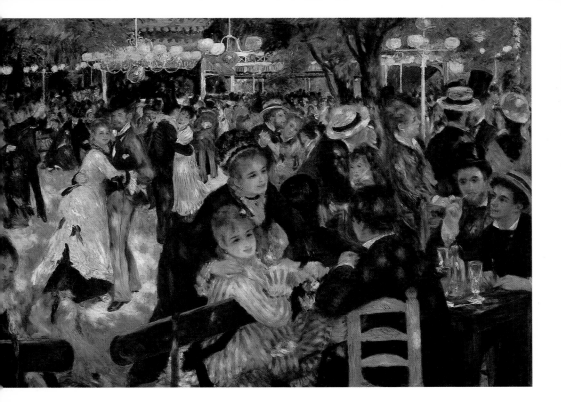

The animation of the canvas is one of the hardest problems of painting. To give life to the work of art is certainly one of the most necessary tasks of the true artist. Everything must serve this end: form, colour, surface. The artist's impression is the life-giving factor, and only this impression can free that of the spectator.

And although the artist must remain master of his craft, the surface, at times raised to the highest pitch of liveliness, should transmit to the beholder the sensation which possessed the artist.

You see that I am in favour of a variation of surface within the same picture. This does not correspond to customary opinion, but I believe it to be correct, particularly when it is a question of rendering a light effect. Because when the sun lets certain parts of a landscape appear soft, it lifts others into sharp relief. These effects of light, which have an almost material expression in nature, must be rendered in material fashion on the canvas.

Alfred Sisley, Letter to Adolphe Tavernier, January 1872

ALFRED SISLEY, VILLAGE BY THE SEINE (VILLENEUVE-LA-GARENNE), 1876

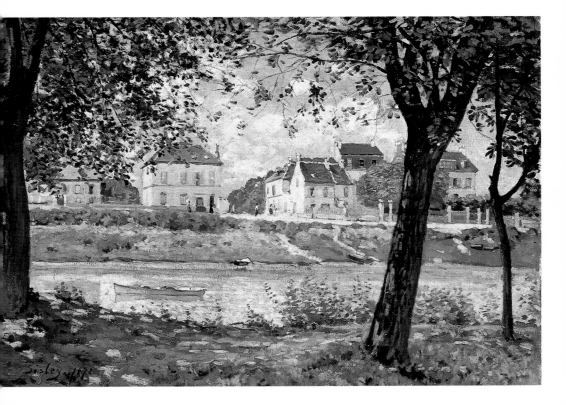

I must tell you that your letter surprised me at Estaque on the sea shore. I am no longer at Aix, I left a month ago. I have started two little motifs with the sea, for Monsieur Chocquet, who had spoken to me about them. It's like a playing card. Red roofs over the blue sea. If the weather becomes favourable I may perhaps carry them through to the end. Up to now I have done nothing – but there are motifs which would need three or four months' work, which would be possible, as the vegetation doesn't change here. The olive and pine trees always keep their leaves. The sun here is so tremendous that it seems to me as if the objects were silhouetted not only in black and white, but in blue, red, brown and violet. I may be mistaken, but this seems to me to be the opposite of modelling. As soon as I can, I shall spend at least a month in these parts, for one must do canvases of two metres at least, like the one by you sold to Faure.

Paul Cézanne, Letter to Camille Pissarro, 2 July 1876

PAUL CÉZANNE, L'ESTAQUE: VIEW OF THE BAY OF MARSEILLES, *c.* 1878-79

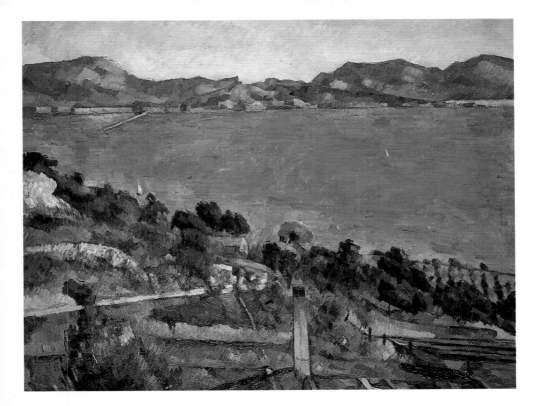

As for Degas, his objects remained what they were; his interest was devoted to the character which Nature, rather than the vision of the artist, had given them. He seized upon the horses, the jockeys, the crowd, the world of the racecourse, with its special colours and lines and its special elegance. He showed how the legs of the jockeys become part of their horses; he revealed the mechanism of the riders intent only on their motion; he depicted the improvised and unpremeditated jostling of the horses at the start, the last minute before the signal is given, what happens before and after the race, and all the things that go on simultaneously in the elegant carriages of the spectators. Curiously enough, he hardly ever painted the actual race in progress. All these things he drew to perfection. There is not a movement which an eye, trained as his was to observe such motion, failed to detect and to seize, and he was able to differentiate between the finest shades in Nature.

Julius Meier-Graefe, *Degas*, 1923

EDGAR DEGAS, AT THE RACES, *c.* 1879

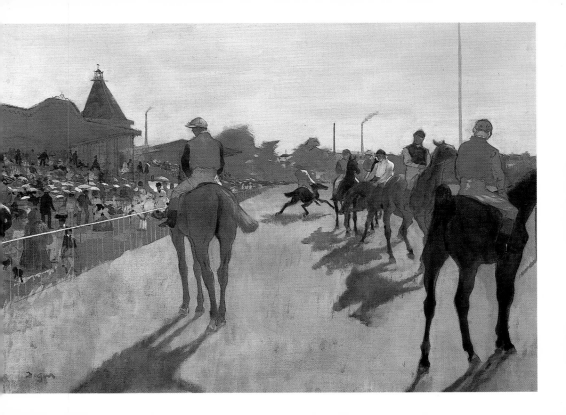

The large 'Boatmen's Luncheon' . . . was the crowning achievement of a long series of pictures, studies and sketches at the Grenouillère Restaurant in Chatou . . . The spot had been discovered by young lovers who liked to wander under the great poplar trees. As outdoor sports were then becoming popular, a far-sighted Bougival hotel-keeper called Fournaise decided to enlarge a small house on the island where he sold lemonade to Sunday visitors. He built a landing-place at the river's edge.

The name 'Grenouillère' [frog-pond] derived not from the numerous batrachians which swarmed in the surrounding fields, but from quite a different species of frog. It was a term applied to ladies of easy virtue: not exactly prostitutes, but rather a class of unattached young women, characteristic of the Parisian scene before and after the Empire, changing lovers easily, satisfying any whim, going nonchalantly from a mansion in the Champs-Elysées to a garret in the Batignolles. To them we owe the memory of a Paris which was brilliant, witty and amusing.

Jean Renoir, *Renoir, My Father*, 1958

PIERRE-AUGUSTE RENOIR, LUNCHEON OF THE BOATING PARTY, 1881

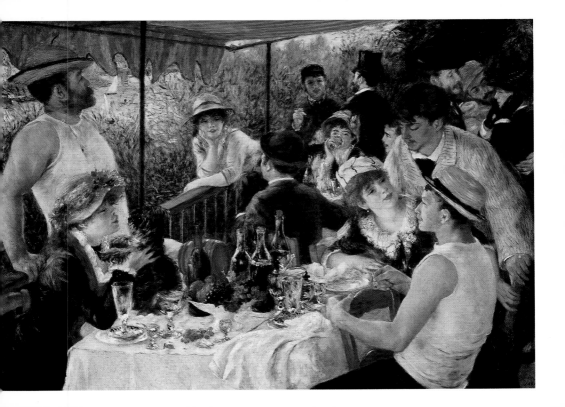

I sat on a chair behind him and watched him at work. Although he painted from life, Manet did not by any means copy it; I realized his great gift for simplification. He began to build up the woman's head, but not by the means that nature offered him. Everything was concentrated; the tones were lighter, the colours brighter, the values more homogeneous. The whole formed a light and tender harmony. We spoke of Chaplin. 'He is very talented, you know,' said Manet, while painting in with small strokes the gold paper around the neck of a champagne bottle.

Other people joined us, and Manet stopped painting to go and sit on the divan against the wall on the right. It was then that I saw how his illness had undermined him. He walked with a stick and appeared to tremble.

Georges Jeanniot, in *La Grande Revue*, 10 April 1907

EDOUARD MANET, BAR AT THE FOLIES-BERGÈRE, 1882

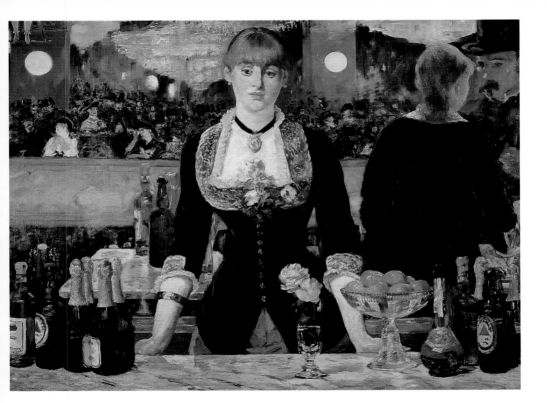

In the present show the clarion call is sounded by Monsieur Seurat. *La Grande Jatte*! They press about it, insult it, mock it. The Goncourt brothers were right: 'A painting on exhibition hears more nonsense than anything else in the world.' *La Grande Jatte* deserves the most careful study. It is luminous, and to such a degree that it is almost impossible to become interested in the other landscapes near it. An atmospheric purity, a total aerial vibration, fills it. The Seine, the green shadow, the golden grass and the sky, influence one another, colour one another, interpenetrate and produce a tremendous sensation of life.

Monsieur Seurat is described as a savant, an alchemist, who knows what? However, he uses his scientific experiments only for the purpose of controlling his vision. They give him an extra degree of sureness. Where is the harm? *La Grande Jatte* is painted with a primitive naïveness and honesty. Looking at it we are reminded of Gothic art.

Emile Verhaeren, in *La Vie Moderne*, 26 February 1887

GEORGES SEURAT, SUNDAY AFTERNOON ON THE ISLAND OF LA GRANDE JATTE, 1884-86

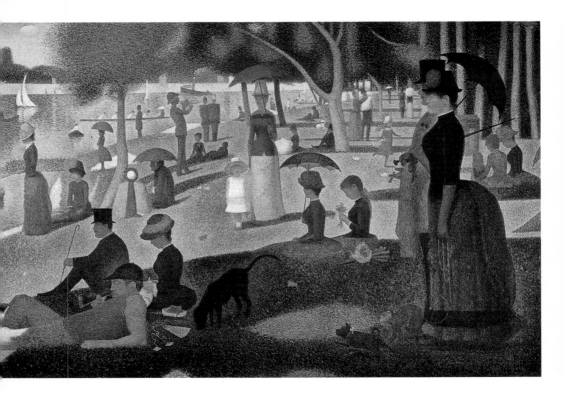

When Monet came to Giverny, he had the little branch of the Epte, swift-running in ripples, just beyond where his garden ended; half a mile off he had the Seine, which had flowed through all his life. But the Seine here was not, as at Argenteuil, mainly the crowded playground of pleasure boats, or as at Vétheuil the highway for long strings of straining barges; though here also he painted its noble breadth with the *coteau* rising beyond and mirrored in its shining surface, or with the tower of Vernon's great church rising in the distance. Here at Giverny a great island, continuing the flat delta of the Epte, is cut off by a narrow arm of the Seine, hidden away by trees interlocking over it, the haunt of anglers in their punts, and of lazy pleasure excursions. He played with the water at first, kept a boat on it, and could slip down to it by his channel of the Epte, and he has painted again and again the stream under its green roof. But presently he wanted more – a piece of water of his own, to adorn after his own fashion; a mirror of the sky at his own door, to set in a frame of his own devising.

Stephen Gwynn, *Claude Monet and his Garden*, 1934

CLAUDE MONET, THE BOAT AT GIVERNY, *c.* 1887

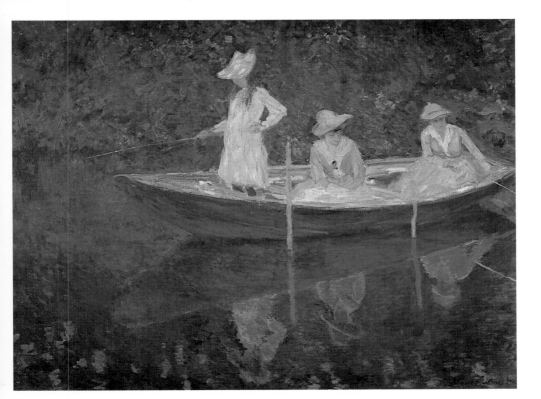

I think a great deal about painting without using dots (pointillism). I hope to succeed, but I haven't yet been able to solve the problem of achieving a pure tone without any harshness – to determine what can be done to retain the qualities of purity and simplicity of the pointillists and yet not lose the breadth, suppleness, freedom, spontaneity and freshness of expression of the Impressionists. This is the crux of my difficulty, and it preoccupies me. For the dot is thin, without consistency, transparent, monotonous rather than simple, even as used by Seurat, especially as used by Seurat.

At this time I am looking for a way to replace the use of dots; up until now I have not found the technique I seek. The execution of my work is not rapid enough, in my opinion, and there is not the instantaneous reaction of the senses which I deem essential.

Camille Pissarro, Letters to Lucien Pissarro, 6 September 1888 and 20 February 1889

CAMILLE PISSARRO, WOMAN IN A FIELD AT ERAGNY, 1887

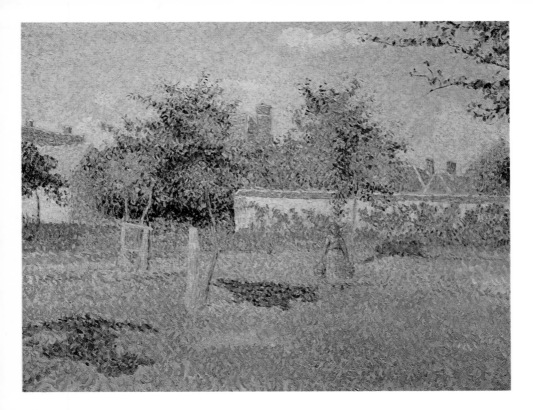

I have just come back with two studies of orchards. Here is a crude sketch of them – the big one is a poor landscape with little cottages, blue skyline of the Alpille foothills, sky white and blue. The foreground, patches of land surrounded by cane hedges, where small peach trees are in bloom – everything is small there, the gardens, the fields, the orchards, and the trees, even the mountains, as in certain Japanese landscapes, which is the reason why the subject attracted me.

Vincent Van Gogh, Letter to Theo, April 1889

VINCENT VAN GOGH, PEACH BLOSSOM IN THE CRAU, 1889

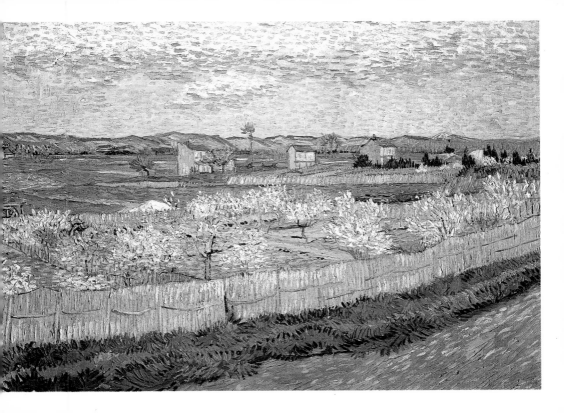

A noisy crowd milled around in the brightly lit haze of reddish dust raised by the quadrille dancers, which settled on the lights and on the gilded ornaments, clouded the mirrors and pictures already dimmed by cigar-smoke . . . The male dancers whirled about quite independently of their partners, whose skirts, festooned with lace, swirled around, revealing through flimsy under-clothing glimpses of delicately rose-tinted flesh.

Gross hands applauded the ever more revealing display, particularly when one of the dancers, sickened by an audience which had paid to see her underclothing and wanted plenty for its money, would flounce towards them and hurl a vulgar or abusive word in the direction of these incorrigibly offensive individuals.

Henri Vernier in *Lautrec by Lautrec*, 1964

HENRI DE TOULOUSE-LAUTREC, DANCE AT THE MOULIN ROUGE, 1890

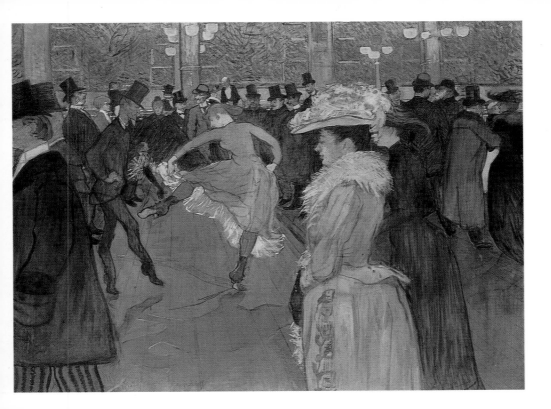

In order to explain my Tahitian art, since it is held to be incomprehensible: as I want to suggest an exuberant and wild nature and a tropical sun which sets on fire everything around it, I have to give my figures an appropriate frame. It really is open-air life, although intimate; in the thickets and the shaded brooks, those whispering women in an immense palace decorated by nature itself with all the riches Tahiti holds. Hence these fabulous colours and this fiery yet softened yet silent air.

But all this does not exist!

Yes, it exists as the equivalent of the grandeur and profundity of this mystery of Tahiti, when it must be expressed on a canvas one metre square.

<div align="center">Paul Gaugin, 'Notes à la suite de Noa-Noa'</div>

<div align="center">PAUL GAUGUIN, MAHANA NO ATUA (DAY OF THE GOD), 1894</div>

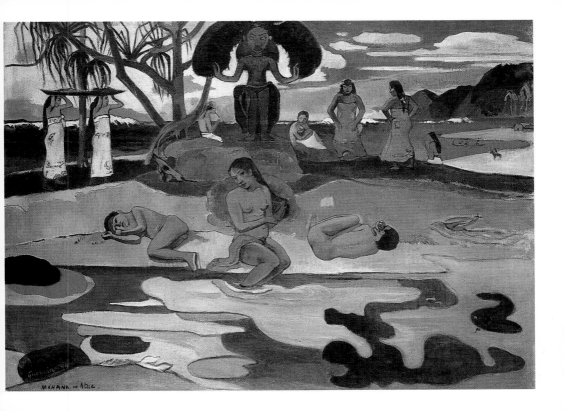

Her exhibition is composed of portraits of children, interiors, gardens . . . in these subjects, so much cherished by the English, Miss Cassatt has known the way to escape from sentimentality on which most of them have foundered.

For the first time, thanks to Miss Cassatt, I have seen the likenesses of enchanting children, quiet bourgeois scenes painted with a delicate and charming tenderness. Furthermore one must repeat, only a woman can paint infancy. There is a special feeling that a man cannot achieve . . . only a woman can pose a child, dress it, adjust pins without pricking themselves . . . This is family life painted with distinction and with love.

J. K. Huysmans, Exhibition reviews, 1880–81

MARY CASSATT, THE BOATING PARTY, 1893-94

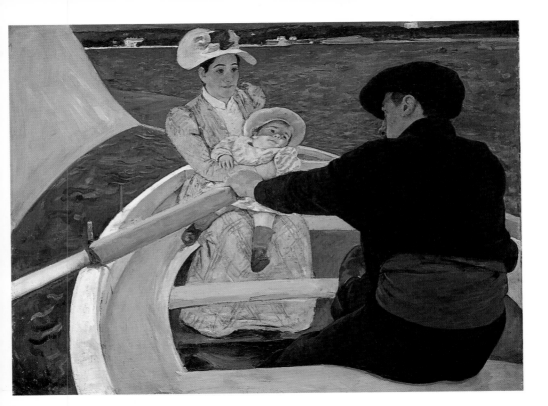

As you know, I have often made sketches of male and female bathers which I should have liked to execute on a large scale and from nature; the lack of models has forced me to limit myself to these rough sketches. There were obstacles in my way; for example, how to find the proper setting for my picture, a setting which would not differ much from the one I visualized in my mind; how to gather together the necessary number of people; how to find men and women willing to undress and remain motionless in the poses I had determined. Moreover, there was the difficulty of carrying about a large canvas, and the thousand difficulties of favourable or unfavourable weather, of a suitable spot in which to work, of the supplies necessary for the execution of such a large work.

Paul Cézanne, Letter to Emile Bernard, March 1904

PAUL CÉZANNE, LES GRANDES BAIGNEUSES, 1900–05

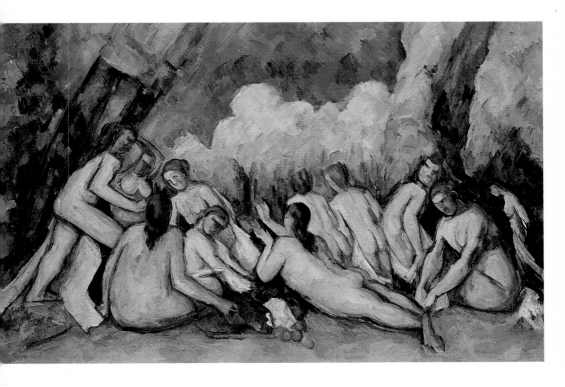

First published in the United States in 1991 by Chronicle Books

Conceived, edited and designed by Russell Ash & Bernard Higton
Copyright © 1990 by Russell Ash & Bernard Higton

Printed in Hong Kong by Imago

ISBN 0-87701-801-4

10 9 8 7 6 5 4 3 2 1

Chronicle Books
275 Fifth Street
San Francisco, CA
94103